# daughters make everyday a gift

pictures and verse
by
Sandra Magsamen

stewart tabori & chang
New York

From the
moment you
were born
my
darling
girl,

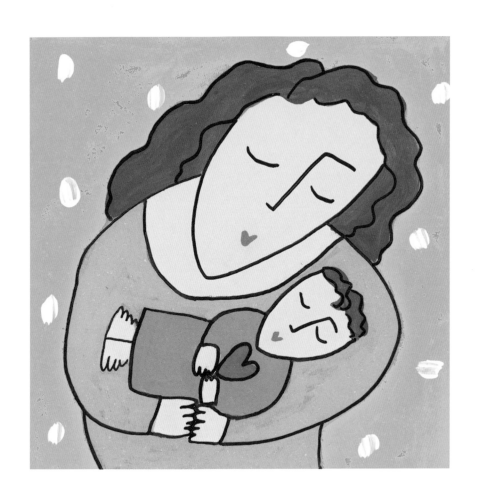

you were
more precious
than diamonds,
rubies or
pearls.

You
are an
amazing
and
beautiful
gift.

You
give my life
meaning and
joy and my
spirit
a lift.

You
are unique
and special,
there is no
one like you.

Thank you
for all that you
are and all
that you
do.

Your smile
brightens
any
day,

and your
laughter
delights in
magical
ways.

Your
kindness and
thoughtfulness
make
me proud.

I want to shout, "this is my daughter" really loud.

Life's lessons are sometimes challenging and difficult too.

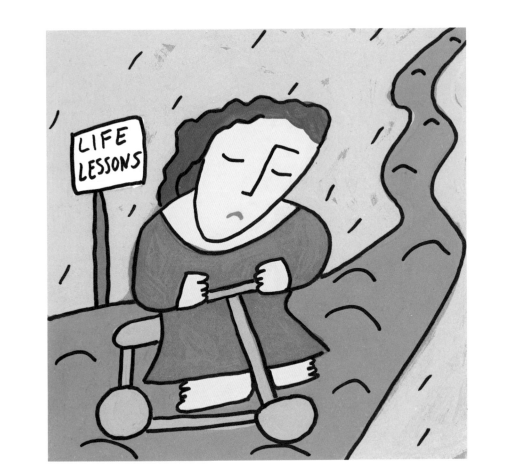

Yet the decisions you've made have given depth, knowledge, and understanding to you.

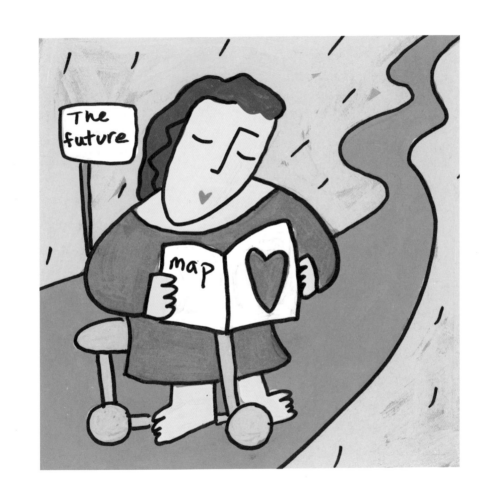

Believe in
yourself,
follow your
dreams, and
reach for the
stars as you live...

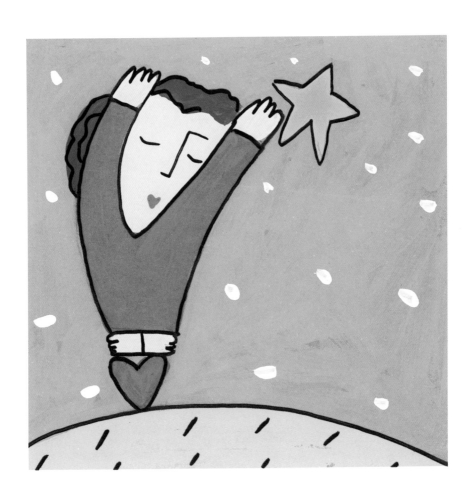

and always
remember
that you
pretty much
get what you
give.

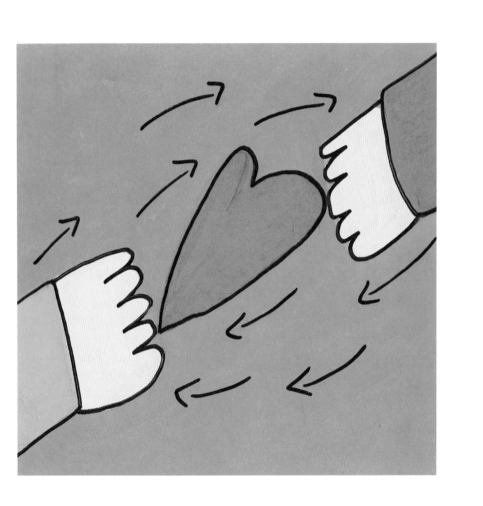

You've been
my treasure
right from
the start; I
love you with
all of my heart.

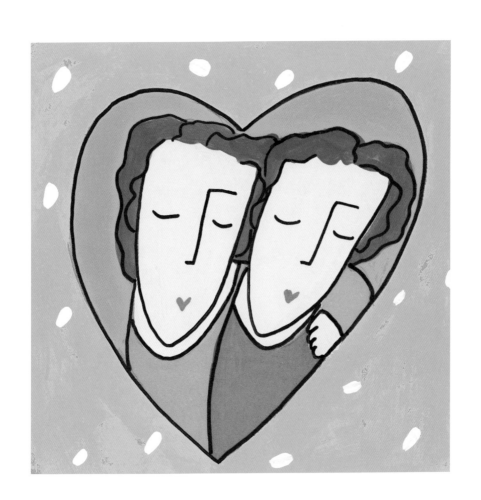

Pictures and verse by Sandra Magsamen
© 2001 Hanny Girl Productions, Inc.

Published in 2001 by
Stewart, Tabori & Chang
115 West 18th Street,
New York, NY 10011
www.abramsbooks.com

ISBN: 1-58479-129-2

Printed in China

10 9 8 7 6 5 4 3

Stewart, Tabori & Chang is a subsidiary of

LA MARTINIÈRE
GROUPE